**A THOMAS NELSON BOOK**

First published in 1993 by Thomas Nelson Publishers,
Nashville, Tennessee.

10   9   8   7   6   5   4   3   2   1

Library of Congress Cataloguing in Publication Data is available.

Library of Congress Card
93-83508

ISBN 0-7852-8309-9

*MINIATURE ART MASTERS*
*GREAT EUROPEAN ARTISTS: MICHELANGELO*
was prepared and produced by
Magnolia Editions Limited,
15 West 26th Street, New York, N.Y. 10010

Editor: Sharyn Rosart
Art Director: Jeff Batzli
Designer: Susan Livingston
Photography Editor: Ede Rothaus

Printed in Hong Kong and bound in China

# Michelangelo

### Gerhard Gruitrooy

**NELSON REGENCY**
A Division of Thomas Nelson, Inc.

## Portrait of Michelangelo
### By Marcello Venusti
Circa 1545; Oil on canvas;
18" × 13 5/8" (45.7 × 34.6 cm);
Casa Buonarotti, Florence

# INTRODUCTION

Michelangelo Buonarotti, a giant of Renaissance art, was born in 1475 in Caprese, in Florentine territory, where his father was a resident magistrate. The family returned to Florence only a few weeks after his birth, and in 1488 Michelangelo was apprenticed to the painter Domenico Ghirlandaio. After about a year, he transferred to a school set up in the Medici Garden, which had been founded by Lorenzo de' Medici. Here Michelangelo studied with the sculptor Bertoldo di Giovanni (1420–1491), and came into contact with other artists, philosophers, poets, and men of letters. The young artist's genius was recognized and encouraged early on. Although Michelangelo later claimed to have had no ordinary workshop training, his apprenticeship with Ghirlandaio

must have been intense enough to familiarize him with the fresco technique and with the works of acknowledged masters, which he copied in drawings.

After the political fortunes of the Medici declined, Michelangelo worked in Bologna, then in Rome, where his *Pietà* brought him immediate fame. Upon his return to Florence in 1501 he received such important commissions as the gigantic statue of *David* and the fresco of the *Battle of Cascina* for the city's Palazzo Vecchio. The latter work was subsequently destroyed, but influenced many artists who saw it. In 1505 Pope Julius II called the artist to Rome and ordered him to design a gigantic tomb that was to include forty large sculptures. Of these, only the *Moses* was actually completed and two *Slaves* largely executed. The "non-finito" (unfinished) was to be-

come a characteristic aspect of Michelangelo's work. After quarreling with the Pope, Michelangelo fled to Florence; only in 1508 were the two men reconciled, and Michelangelo began his most important work, the ceiling in the Sistine Chapel. The Pope was impatient to see it finished and the artist worked virtually alone for four hard years on this gigantic masterpiece. Upon its completion, Michelangelo was universally regarded as the world's greatest living artist.

After the Pope's death in 1515, Michelangelo returned to Florence, where he worked on various projects for the Medici family, notably the Medici Funerary Chapel. In 1527 the Medici were again expelled from Florence and Michelangelo worked as an engineer, designing fortresses to help defend the

city. After the return of the Medici to power, he was pardoned and worked for the Medici until 1534, when he left his city to settle in Rome, where he spent the last thirty years of his life.

In Rome, Michelangelo was immediately commissioned to paint the *Last Judgement* in the Sistine Chapel, a project that lasted from 1534 to 1541. The last two decades of his life saw him engaged as chief architect of the new St. Peter's, built to replace the old early Christian structure. Its majestic dome is among his finest achievements. Michelangelo also wrote much fine poetry in his later years, but his written works were not fully published until the nineteenth century. During this time he also worked on several *Pietàs*, which he intended for his own tomb. He died on February 18, 1564, and was even-

tually buried in Santa Croce, Florence. Two biographies written during his lifetime recognized him as the greatest sculptor, painter, and draughtsman ever. He remains the prototype of genius.

## MADONNA DELLA SCALA

1489–1492; MARBLE RELIEF;
21 $\frac{7}{8}$" × 15 $\frac{3}{4}$" (55.5 × 40 CM);
CASA BUONAROTTI, FLORENCE

This relief is probably the earliest testimony of Michelangelo as a sculptor and artist. It is preserved today in a house that he had bought for his nephew and that is now called Casa Buonarotti after Michelangelo's family name. The *Madonna della Scala* (Madonna of the Stairs) is an extremely flat relief, but the artist handled this challenge with great mastery, creating various levels of depth. The Madonna is sitting on a stone block with her feet crossed while breast-feeding the child, whose head is partially covered by her cloak.

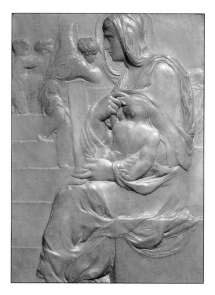

## BATTLE BETWEEN CENTAURS AND LAPITHS

CIRCA 1492; MARBLE RELIEF;
32 1/4" × 35 5/8" (84.5 × 90.5 CM);
CASA BUONAROTTI, FLORENCE

Although the precise subject of this work has not been entirely clarified, it is generally agreed that this scene represents a battle between centaurs, the mythological creatures that were half human, half equine, and Lapiths, who were giants. The turbulent composition with its numerous entwined figures contains characteristics of Michelangelo's future style: dramatic gestures, muscular bodies in motion, and heroic subjects. The oldest documents mention the relief already in its present location.

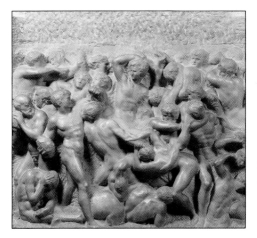

## CRUCIFIX

1492–1493; POLYCHROME WOOD;
53 ⅛" × 53 ⅛" (135 × 135 CM);
CASA BUONAROTTI, FLORENCE

Executed for the prior of Santo Spirito monastery in Florence, this crucifix was believed lost in the last century until its rediscovery under heavy overpaint in 1962. The somewhat less-than-life-size figure of a youthful Christ is idealized, transcendent, already beyond suffering. His head is bent down as a sign of acceptance of His death. The slender, harmonious proportions of the body stress the unheroic character of the event.

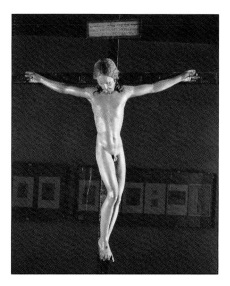

## KNEELING ANGEL WITH CANDELABRUM
1494–1495; MARBLE;
HEIGHT 20 ¼" (51.5CM);
SAN DOMENICO, BOLOGNA

To escape the threat of a French invasion led by
Charles VIII, Michelangelo left Florence first for
Venice, then for Bologna, where he spent almost a
year. For the decoration of the altar of the church
of San Domenico he sculpted this angel carrying a
candelabrum. The condensed volume and dynamic
force of the figure go beyond the tradition of sweet
smiling angels. These characteristics were later
elaborated upon in the statue of *David* and the
youths of the Sistine Chapel.

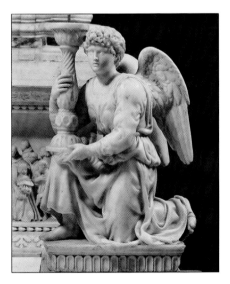

## BACCHUS

CIRCA 1496; MARBLE;
HEIGHT 72 ½" (184 cm);
MUSEO NAZIONALE DEL BARGELLO, FLORENCE

The first sculpture the artist made after his arrival in Rome in 1496 was *Bacchus,* a commission from his host and patron, Cardinal Riario. When the work was rejected, however, Michelangelo sold it instead to the banker Jacopo Galli, who placed it in his garden. Bacchus, the ancient Greek god of wine, is shown with his traditional attributes: a cup, grapes and vine leaves, and a little satyr, symbol of excess and lust. It is not easy to place this sculpture in Michelangelo's artistic development, although the same pure and idealized beauty of the body can be found in the figure of Christ in the *Crucifix* (see page 14).

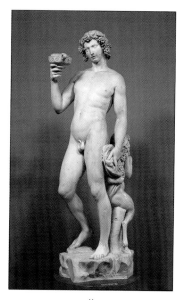

# Pietà

1498–1499; Marble; Height 68 ½"
(174 cm), Depth 28 ⅛"(69 cm);
St. Peter's Basilica, Rome

Probably Michelangelo's most celebrated work and the only one that he proudly signed: "Michelangelo Buonarotti Florentine Made This" (written in a contracted Latin form on the sling running across the Madonna's chest). The perfect balance between the two figures, the refined handling of the marble, and the poetic expressions of this pair make the *Pietà* a hallmark in the history of sculpture. The Madonna's youthful appearance as the "Mother of God" has a theological explanation: she represents the immaculate Virgin who is free of sin. The sculpture was moved to its present location in the first chapel on the right in 1749.

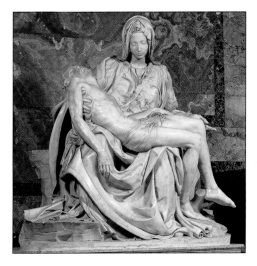

## MADONNA OF BRUGES

1498–1501; MARBLE; HEIGHT 37"
(94CM), WITH BASE 50 ³/₈" (128CM);
NOTRE-DAME, BRUGES

This group is constructed in the solemn architectural form of a triangle. The Madonna's head is simpler, more heroic than that of the *Pietà* (see page 20), but also more detached from the Christ Child, who almost seems to slip away from His mother. For reasons that elude us, Michelangelo kept this work away from unwanted observers until it was shipped to Bruges, where it was placed in the cathedral on the altar of the Italian Moscheroni family. Albrecht Dürer saw it there during his visit in 1521. This was the only work Michelangelo sent abroad. Eventually a papal order made any export of his works illegal.

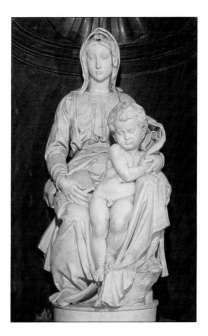

## MADONNA AND CHILD WITH ST. JOHN (TONDO PITTI)

CIRCA 1503; MARBLE RELIEF;
33 ⅝" × 32 ¼" (85.5 × 82 CM);
MUSEO NAZIONALE DEL BARGELLO, FLORENCE

The dynamic circle of this *tondo* (roundel) is interrupted by the Madonna's monumental, expressive head and by the cube that serves as her throne. The three-dimensionality of the figures deepens from St. John the Baptist on the left to the Christ Child on the right, culminating in the Virgin's towering presence at the center. The work received its name from Bartolomeo Pitti, a member of the wealthy noble family that commissioned this relief from Michelangelo.

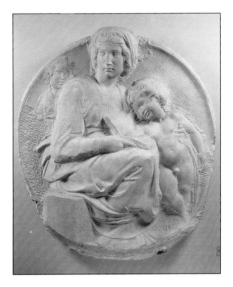

# David

1501–1504; Marble;
Height 161 ½" (410 cm);
Galleria dell'Accademia, Florence

A contract for a figure of David was signed between the artist and the workshop of the cathedral of Florence in 1501. Michelangelo was offered a "badly hewn" block of marble, which he turned into this giant symbol of civic pride. David is shown not after the fight with Goliath but before it, his gaze fixed on his adversary and his sling ready. The success of this powerful, self-contained figure was immediate and a committee of artists decided to place the sculpture next to the entrance of the Palazzo Vecchio in the city's main square. For reasons of conservation the original has now been replaced with a copy.

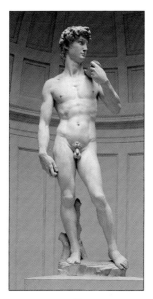

## THE DYING SLAVE
CIRCA 1513; MARBLE;
HEIGHT 84 ⅝" (215 CM); LOUVRE, PARIS

In 1505 Pope Julius II invited Michelangelo to Rome and asked him to build a tomb to be erected in St. Peter's. The ambitious project turned out to be a nightmare for the artist, who worked on it for almost forty years through numerous difficulties with Julius and later, his heirs. The final arrangement in San Pietro in Vincoli is a far cry from the artist's original idea (see also pages 30 and 40). This figure belongs to a group of slaves that was intended to decorate the base of the tomb structure. Eventually, the slave ended up in France together with a companion piece; it is now preserved in the Louvre.

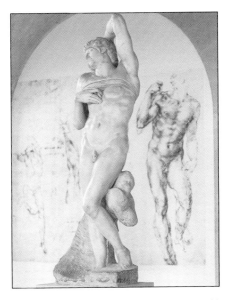

# MOSES

CIRCA 1515; MARBLE; HEIGHT 92 ½"
(235CM); SAN PIETRO IN VINCOLI, ROME

Now the centerpiece of the fragmentary tomb of
Pope Julius II (see also pages 28 and 40), the
voluminous figure of *Moses* appears even more
impressive than originally intended. His powerful
pose, long beard, and terrifying look have an
extraordinary presence and unrivaled immediacy.
The horns on Moses' head were a traditional fea-
ture based on an erroneous translation of the Bible
that confused the word for horns with that for
rays (of illuminating wisdom). Sigmund Freud was
inspired by this sculpture to write his treatise
*Moses and Monotheism.*

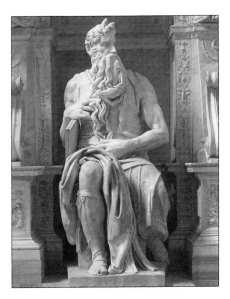

## CHRIST RISEN

1518–1520; MARBLE;
HEIGHT 80 ⅝" (205 CM);
SANTA MARIA SOPRA MINERVA, ROME

In 1514, the artist received a commission for a life-size standing figure of Christ, naked and holding a cross "in a pose such as the master would deem appropriate." Because of a black streak that flawed the marble in Christ's face, Michelangelo temporarily abandoned the project. He started all over again with a new block and finished the work with the assistance of pupils. Christ stands erect, holding the instruments of His Passion (the scourge, the rod, and the sponge) with both hands. The bronze loincloth is a modern addition.

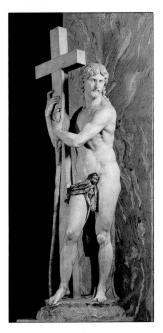

# TOMB OF GIULIANO DE' MEDICI

CIRCA 1531–1534;
MEDICI CHAPELS, SAN LORENZO, FLORENCE

The first plans for a funerary chapel for the illustrious members of the Medici family were designed in 1520, but the project dragged on for many years and was ultimately left unfinished. In addition to the brilliant overall architectural design, the two most important accomplishments are the tombs for Giuliano and Lorenzo de' Medici (see page 36). Seated in a niche above the sarcophagus with the figures of "Night" and "Day," Giuliano is shown as a determined and energetic person. Other statues were planned for the niches to the left and right, but they were never executed.

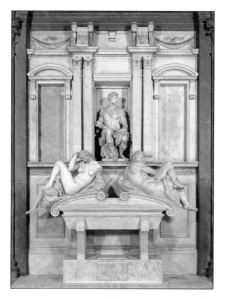

## TOMB OF LORENZO DE' MEDICI (DETAIL OF CENTER)
CIRCA 1526–1534;
MEDICI CHAPELS, SAN LORENZO, FLORENCE

If Giuliano has sometimes been interpreted as a symbol of the "active life" *(vita activa)* then Lorenzo stands for the "passive" or "contemplative life" *(vita contemplativa)*. Dressed in his armor, he wears a helmet with a lion's head. Lorenzo takes a thoughtful pose, his left hand placed on his chin with the index finger touching his lips. In a way he is a precursor of Rodin's *Thinker*. The two figures on the sarcophagus below represent "Evening" and "Morning."

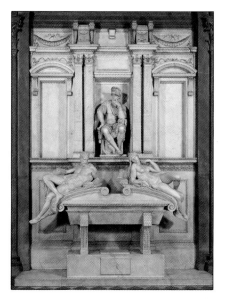

# THE FIGURE OF NIGHT

1526–1531; MARBLE;
LENGTH 76 3/8" (194CM);
MEDICI CHAPELS, SAN LORENZO, FLORENCE

The figure of "Night" from the tomb of Giuliano de' Medici (see page 34) is perhaps Michelangelo's most mysterious sculpture. It has frequently been noted that her body is strongly masculine and that her breasts look as if they had been added onto the body. Around her are an owl, poppies, and a mask, all symbols of night and sleep. Michelangelo himself helped his creation to gain even wider fame by writing a sonnet about the "Night." She was among the first sculptures in the Medici Chapels to be finished and put in place.

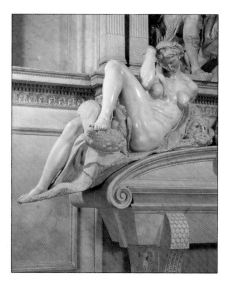

## AWAKENING SLAVE

CIRCA 1530–1534; MARBLE;
HEIGHT 105 ⅛" (267CM);
GALLERIA DELL'ACCADEMIA, FLORENCE

Together with three other unfinished slaves this
work was destined for the tomb of Pope Julius II in
Rome (see pages 28 and 30). The figures never
left Michelangelo's studio in Florence and were
later given by the artist's nephew to Grand Duke
Cosimo I of Tuscany, who placed them in a grotto
in the Boboli Gardens near the Palazzo Pitti in
Florence. This "work in progress" offers a rare
insight into Michelangelo's procedures. The basic
idea of the figure has already been laid out with
significant precision. Even in its incomplete state
this sculpture leaves a deep impression. Its title
derives from the figure's "stretching" pose.

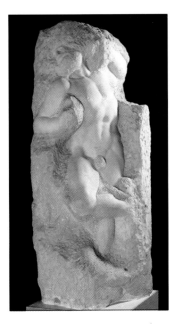

## VICTORY

1532–1534; MARBLE;
HEIGHT 102 ¾" (261 CM);
PALAZZO VECCHIO, FLORENCE

In all likelihood, this work was part of the aborted project of the tomb for Pope Julius II in Rome (see also pages 28, 30, and 40). The athletic youth has put his knee on the back of a bearded old man, possibly signifying the submission of the provinces during the Pope's reign. The sculpture remained in Michelangelo's studio in Florence until his death in 1564. His heirs planned to put it on the artist's tomb in Santa Croce, but this never came to pass. Instead, it was donated to Grand Duke Cosimo I of Tuscany.

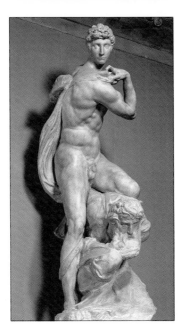

# PIETÀ
1550–1555; MARBLE;
HEIGHT 89" (226CM);
MUSEUM OF THE CATHEDRAL, FLORENCE

While trying to change the position of Christ's legs in this *Pietà* group, Michelangelo uncovered an imperfection in the marble that caused the sculpture-in-progress to break. Michelangelo's early biographers report that the artist had originally wished to have this sculpture placed in his own tomb, which was to be built in Santa Maria Maggiore in Rome; he must have changed his mind, however, since he eventually sold the work in its unfinished state and decided to be buried in his native Florence instead. The figure of Nicodemus with his hooded head might be a self portrait.

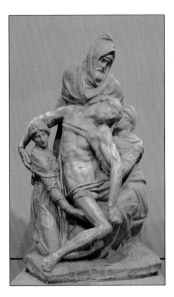

## PIETÀ RONDANINI
1552–1564; MARBLE;
HEIGHT 76 ³/₄" (195CM);
MUSEO DEL CASTELLO SFORZESCO, MILAN

This is the fourth and last *Pietà* Michelangelo created. He appears to have worked on it until the very last days of his life. The group is a fragment, partially destroyed by his own hands, and was found in his studio at his death. The emotional character of the work might suggest that Michelangelo intended it for his own tomb. However, for centuries the statue was preserved in the courtyard of the Palazzo Rondanini in Rome, from which its name was derived. Eventually purchased for the museum, it entered the collection as late as 1952.

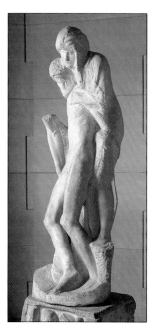

## HOLY FAMILY WITH ST. JOHN THE BAPTIST (TONDO DONI)

1504–1506; TEMPERA ON WOOD;
47 ¼" (120 CM); UFFIZI, FLORENCE

In this roundel, St. Joseph is handing over the Christ Child to the Virgin Mary who, shown with a book on her lap, has interrupted her reading. The nude youths in the background contrast with the principal figures and might symbolize the pagan world before the arrival of Christ. The twisted movement of the main figures and their compact arrangement in a pyramidal block are reminiscent of sculpture groups while the bright colors and the complex composition foreshadow the coming Mannerist style. The *Tondo Doni* is named after its first owner, the Florentine Doni family. The sculpted frame is original.

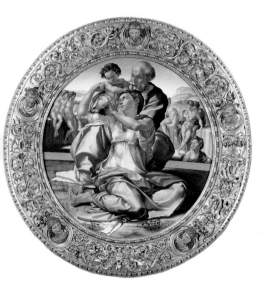

## VIEW OF THE SISTINE CHAPEL CEILING AND LAST JUDGEMENT

SISTINE CHAPEL, VATICAN

The Sistine Chapel is located inside Vatican City and was originally built around 1475 as a private chapel for Pope Sixtus IV. It is a rectangular brick structure about 132 feet (39.6m) long and 44 feet (13.2m) wide. A shallow barrel-vault flattened on the top arcs over the space at a height of 68 feet (20.4m). When Michelangelo was asked to paint the ceiling, it was very simply painted in blue with golden stars to represent heaven or the sky. The walls on the left and right had already been painted with frescoes by various other artists, including Botticelli. The *Last Judgement* on the altar wall was executed by Michelangelo almost thirty years after he painted the ceiling.

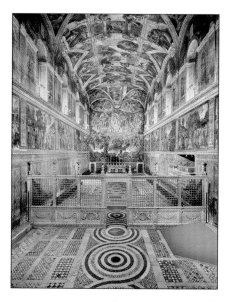

## SECTION OF THE CEILING (FROM THE CREATION TO THE FLOOD)

1508–1512; FRESCO;
SISTINE CHAPEL, VATICAN

Michelangelo divided the vast area of the ceiling with a painted architectural framework, then filled the rectangular central fields with small and large panels that appear open to the sky. At the top are scenes from Genesis, including the Creation of the World, the Story of Adam and Eve, the Expulsion from Paradise, and the Story of Noah. The histories begin over the altar and work away from it in sequence. Below these are scenes of twelve throned figures, of which seven are prophets and five are sibyls, framed by the nude youths known as *ignudi*. The English painter Sir Joshua Reynolds later called Michelangelo's frescoes "the language of gods."

## CREATION OF STARS AND PLANETS (CREATION OF SUN AND MOON)

1511; FRESCO; ABOUT 110" × 224" (280 × 570 CM); SISTINE CHAPEL, VATICAN

This panel is full of sweeping action. Floating on a cloud supported by angels, the massive figure of God roars forward with arms spread wide to order the sun and the moon to their allotted places. Positioned at the left of the fresco, He is hastening forward into the infinite space to perform new tasks of the Creation. The figure of God clearly foreshadows that of Moses, which Michelangelo was to carve a few years later (see page 30). No other artist before or after Michelangelo conceived the act of divine creation with such overwhelming and dynamic power.

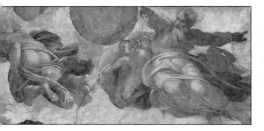

## Separation of Land and Water
1511; Fresco;
About 61″ × 106″ (155 × 270 cm);
Sistine Chapel, Vatican

This is one of the smaller panels of the ceiling that are framed by four of the naked youths called *ignudi* (see also page 52). Here God floats gently toward us, dividing the waters from the earth with a determined, but gentle, gesture. His right palm seems to push through the surface in the act of separating the elements. The blue area behind the group of angels signifies the water, while the plain horizontal stripe on the bottom is the earth. The image of a bearded God the Father, both kind and terrifying, is consistent throughout the Chapel.

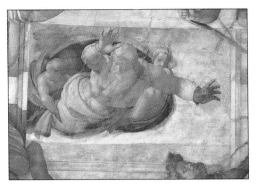

## CREATION OF ADAM

1510; FRESCO;
ABOUT 110" × 224" (280 × 570 CM);
SISTINE CHAPEL, VATICAN

Giorgio Vasari, a contemporary of the artist and his first biographer, said about this famous scene: "Adam [is] a figure whose beauty, pose, and contours are such that it seems to have been fashioned that very moment by the first and supreme creator rather than by the drawing and brush of a mortal man." The narrow space between the fingers of God and His creation is more suggestive of the first divine spark of life transmitted by God than any other comparable image. By merely suggesting this most crucial moment of the whole creation, Michelangelo evoked an overwhelming sense of reverence and awe.

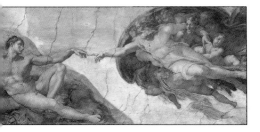

## THE FALL OF MAN AND
## THE EXPULSION FROM PARADISE

1509–1510; FRESCO;
ABOUT 110″ × 224″ (280 × 570 CM);
SISTINE CHAPEL, VATICAN

Here two consecutive scenes are combined in
one panel. On the left, the Fall of Man shows
Eve reaching for the apple offered to her by the
Serpent, whose body is twisted around the tree.
On the right, the Expulsion from Paradise shows an
angel pointing his sword at Adam. For this section,
Michelangelo concentrated on the nude figures,
treating the landscape purely as a stage-setting.
The effect was to heighten the immediacy of the
event, leaving action undisturbed by narrative
descriptions. The painful exile of humankind begins
with this event.

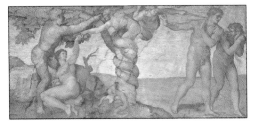

## NOAH'S DRUNKENNESS
1509; FRESCO;
ABOUT 67" × 102" (170 × 260 CM);
SISTINE CHAPEL, VATICAN

After having imbibed too much wine, Noah has fallen asleep next to a vat and a jug. His son Cam mocks his father in the foreground and another son covers him with a veil, while the third son, Sem, reprimands the mocker. In the background the patriarch is seen planting the vines. The recent restoration of the ceiling brought back the original vibrant colors that had been hidden under layers of varnish and dirt.

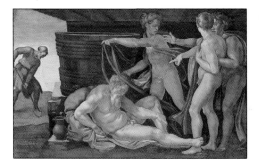

## DELPHIC SIBYL
1509; FRESCO;
ABOUT 138" × 150" (350 × 380 CM);
SISTINE CHAPEL, VATICAN

These pagan sibyls, taken from classical Greek mythology, were the ancients' prophetesses. Usually they foresaw disasters and expressed their knowledge in riddles that were difficult to decipher. The Delphic Sibyl is one of the most delicate images of the whole ceiling. Seated on a throne-like bench, she gazes abstractedly in front of her with a suggestion of doubt on her face. The viewer is very much aware that she has something important on her mind. Stylistically, the sibyl is related to Michelangelo's early Madonnas.

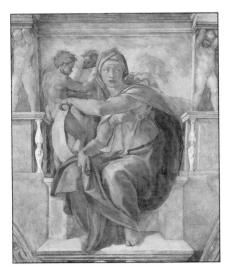

## LIBYAN SIBYL

CIRCA 1511–1512; FRESCO;
ABOUT 156″ × 150″ (395 × 380 CM);
SISTINE CHAPEL, VATICAN

The Libyan Sibyl turns away from us with a gesture that seems to indicate she is closing her book. Her twisted figure seems to move into the back of the picture, creating an almost three-dimensional effect. Like the prophets (see pages 70 and 72) the sibyls appear to be much larger than they really are. The power of these figures is not due to their superhuman size but mostly to their isolation. Each of them seems totally absorbed in an act of spiritual contemplation and intuition. They seem to personify the divine spirit that speaks through them.

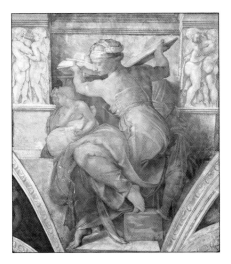

## STUDIES FOR THE LIBYAN SIBYL

CIRCA 1508–1512; RED CHALK;
11 ³⁄₈" × 8 ³⁄₈" (28.9 × 21.4 CM);
METROPOLITAN MUSEUM OF ART, NEW YORK

In order to prepare the multitude of figures for the Sistine ceiling Michelangelo must have made numerous drawings, studies, and cartoons (elaborate, preparatory, 1:1 scale drawings). However, the artist intentionally destroyed them some time before his death so as not to record for posterity the struggles that he endured in creating the final figures. This sheet is one of the few drawings for this project that has survived. This nude study was clearly made in preparation for the Libyan Sibyl. It also includes some details of foot and thumb that show the great care with which the artist approached this project.

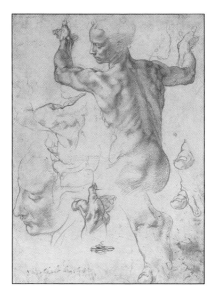

## PROPHET ISAIAH

1509; FRESCO;
ABOUT 144" × 150" (365 × 380 CM);
SISTINE CHAPEL, VATICAN

The prophets and sibyls (see pages 64 and 66) all have distinct individual characters. Isaiah, shown here as a young man, has been reading; his fingers still rest between the pages to mark a particular passage. He has his head turned to his right as if listening to a voice to which one of the youths behind him draws his attention: "Behold, a virgin shall conceive, and bear a son, and shall call his name Immanuel" (Isaiah 7:14). Isaiah appears as the most intellectual and sophisticated of all the prophets.

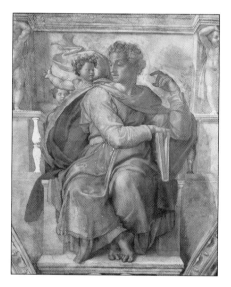

## PROPHET JONAH

1511; FRESCO;
ABOUT 157" × 150" (400 × 380 CM);
SISTINE CHAPEL, VATICAN

Jonah, one of the minor prophets, was certainly a peculiar choice. He was a disobedient prophet who first fled God's call, then rebelled against it, declaring: "I do well to be angry, even until death" (Jonah 4:9). It can only be understood as Michelangelo's own wilfulness of spirit that he dared to place this figure above the Pope's altar. Indeed, the artist was constantly struggling with the Pope's authority, which he attempted to defy more than once—but without success.

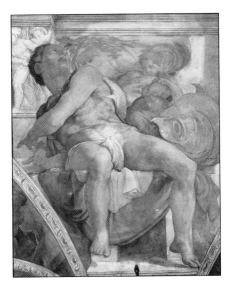

# Figures of Nude Youths
## (*Ignudi* above the Prophet Jeremiah)

1511; Fresco;
78 ¾" × 155 ½" (200 × 395cm);
Sistine Chapel, Vatican

> The nude youths, called *ignudi* in Italian, frame the smaller central panels of the ceiling. There are twenty of them, all well-defined figures outlined with the linear precision of a great draughtsman. Michelangelo was often in great physical and emotional distress during his work on the ceiling, which he described as the "greatest physical labor." And he wrote: "I have no friends of any kind and I don't want any; I don't have the time that I can eat what I need: therefore let me have no more trouble for I cannot stand another ounce."

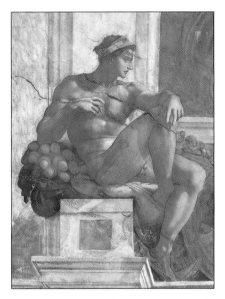

## DAVID AND GOLIATH

1509; FRESCO;
ABOUT 224″ × 382″ (570 × 970 CM);
SISTINE CHAPEL, VATICAN

For the four corner spandrels Michelangelo painted
episodes from the Old Testament, including scenes
of the miraculous salvations of the people of Israel.
In one of them we see David preparing for the
deadly strike, while in a desperate final effort
Goliath tries to raise his head and look up at his
adversary. The tent in the background corresponds
to the irregular shape of the scene, which is due
to the vaulted ceiling.

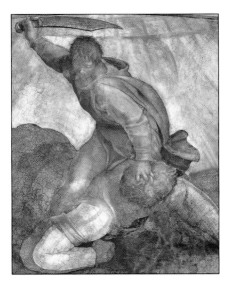

## ELEAZAR AND MATHAN

1511–1512; FRESCO;
ABOUT 85" × 169" (215 × 430 CM);
SISTINE CHAPEL, VATICAN

The lunettes on the wall above the windows are
decorated with figures of the ancestors of Christ,
which were executed after the ceiling frescoes
had been completed and temporarily unveiled in
August 1511. At the center of each scene appear
the names, which are derived from the Gospel
after St. Matthew. Instead of individualized
portraits, Michelangelo chose to depict family
scenes. The artist's melancholy disposition
imparted a note of tragedy to these scenes.

## CHRIST JUDGING AND THE VIRGIN
### (DETAIL FROM *LAST JUDGEMENT*)

1537–1541; FRESCO; TOTAL SIZE
44' 11 $^{3}/_{8}$" × 40' $^{1}/_{4}$" (1370 × 1220 CM);
SISTINE CHAPEL, VATICAN

Twenty-five years after he had started the decoration of the ceiling Michelangelo began to paint the *Last Judgement* on the back wall of the chapel behind the altar at the request of Pope Paul III. The focal point of the vast fresco, which took him seven years to finish, is the majestic figure of Christ sitting before a yellow light. Next to him is the Virgin, dressed in a red and blue cloak. The powerful and splendid figure of Christ as Judge has almost superhuman proportions, enabling it to dominate the composition both physically and psychologically.

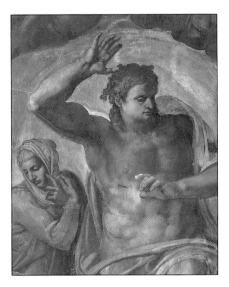

## St. Bartholomew (detail from *Last Judgement*)
1537–1541; Fresco;
Sistine Chapel, Vatican

> Below the figure of Christ appears St. Bartholomew, the apostle and martyr of the Church who was flayed for his faith. The Saint bears the features of the poet Pietro Aretino, but on the skin that he is holding, Michelangelo's own likeness is depicted. This is a terrifying indication of the state of mind of the artist, who worked for years under the hardest conditions in this chapel.

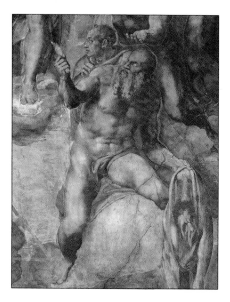

# FIGURE OF A DAMNED
## (DETAIL FROM *LAST JUDGEMENT*)
1537–1541; FRESCO;
SISTINE CHAPEL, VATICAN

Among the many expressive figures of the *Last Judgement*, this is perhaps one of the most moving images. This damned soul, his face contorted in horror and despair, is being pulled down to hell by a satanic monster that has clasped its arms around the victim's legs. Several years after the fresco was unveiled, some of its nude figures were clothed because they were considered indecent. Michelangelo, told about these plans, responded, "Tell his Holiness that this is a small matter—let him look to the setting of the world in order; to reform a picture costs no trouble."

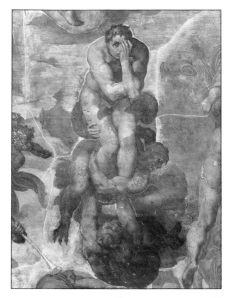

# Dome of St. Peter's Basilica
1546–1564 (COMPLETED IN 1590);
St. Peter's, Rome

> For the last thirty years of his life Michelangelo's main preoccupation was architecture. His last work was the dome of St. Peter's Basilica, which was actually completed years after the artist's death. The large and massive dome is drawn upward by the raised curve of the cupola, the tall lantern, the ribs, and other features. The projecting and retracting elements give the great dome a strong sculptural quality. The whole design was so successful that few other domes built in the following three centuries have failed to acknowledge their debt to Michelangelo.

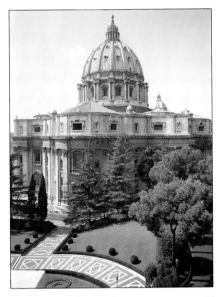

# INDEX OF ARTWORKS